To: _____

From: _____

Stardate: _____

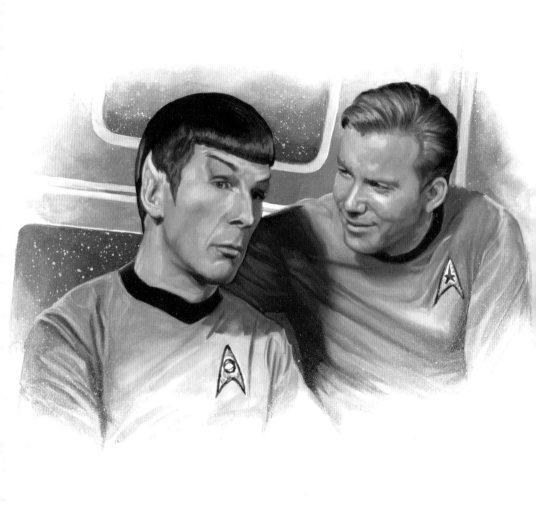

THE *STAR TREK*™
BOOK OF FRIENDSHIP

THE STAR TREK™

BOOK OF FRIENDSHIP

You Have Been, and Always Shall Be, My Friend

Robb Pearlman & Jordan Hoffman
Foreword by Robert Picardo & Ethan Phillips
Illustrations by J. K. Woodward
with special guest appearance by Erin Macdonald

Smart Pop Books
An Imprint of BenBella Books, Inc.
Dallas, TX

Smart Pop is an imprint of BenBella Books, Inc.
10440 N. Central Expressway, Suite 800
Dallas, TX 75231
smartpopbooks.com
benbellabooks.com
Send feedback to feedback@benbellabooks.com

BenBella and *Smart Pop* are federally registered trademarks.

Printed in the United States of America
10 9 8 7 6 5 4 3 2 1

Library of Congress Control Number: 2021040578
ISBN 9781637740514 (hardcover)
ISBN 9781637740521 (electronic)

Editing by Vy Tran
Copyediting by Athena Lakri
Text design and composition by Aaron Edmiston
Cover design by Brigid Pearson
Printed by Versa Press

Special discounts for bulk sales are available. Please contact bulkorders@benbellabooks.com.

FOREWORD

Robert: Please state the nature of your emergency.

Ethan: We need to talk about *Star Trek*, friendship, and our friendship.

R: That's not an emergency.

E: They said we were on a deadline.

R: Well, it's always a thrill when I get to speak to you, my good friend.

E: I love seeing you, too. Although I am going a little bit blind from the glare. You usually wear a hat.

R: As if *you* have any right to make bald jokes. I've often said that if you put me in a dryer for forty-five minutes, you get Ethan Phillips.

E: I've said that, too. Friends can do that. You know, a lot of people may not realize we actually were friends before I was ever Neelix and you were The Doctor.

R: Yes, I distinctly remember meeting you that first time, in the late 1970s. We were both at a party and someone said, "Oh, you two should definitely meet." I forget who said it, but we were in a kitchen, I remember that much. And they were right!

E: I'd loved watching you perform through the years. I saw you play a vampire in *The Howling*. You said, "I'm going to give you a piece of my mind," and pulled a thing out of your head. I remember sitting in the audience and thinking, "This guy is incredible!"

R: I was a werewolf, actually, but thank you. There were many, many times when we were up for the same jobs. I think, in the end, we each got around the same number of roles, but I stopped keeping track.

E: Oh, I've got all the data on an old computer. But we did get to work together, too. Prior to *Star Trek* we were both in a movie called *Wagon's East.* And there was a part I had my eye on. I asked if I could read for that and they said, "Oh, we've already got someone." I asked who and, of course, they said, "Bob Picardo." Real nice! But years before that, when I wrote the play *Penguin Blues,* you helped me out by doing the first reading. It took a great casting director to point out the obvious, that you knew my rhythms and sensibilities. The play went on to be a real success, and I'll never forget that.

R: Do you remember what happened when they wanted to bring in two new characters on the second season of "Benson"? You landed the part of the enthusiastic and maybe a little bumbly press secretary, and our dearly missed *Star Trek* friend, the late René Auberjonois, was perfectly cast as the arch, cranky chief of staff. But who did they test for both roles? Me! I canceled myself out as being somewhere between

exuberant and fussy. We both read for the Coen Brothers for your role in *Inside Llewyn Davis*, too. That one went down to the wire.

E: And when I got the part you called me and were so genuinely thrilled for me. So few actors would ever do that, really. I mean, when the Coens later cast you in *Hail, Caesar!* I was so steamed I wasn't up for that part! I'm joking, I'm joking.

R: You know, when I first read for The Doctor, he had a total of nine lines and was described as "colorless, humorless, a computer program of a doctor." This did not sound like a bucket of fun, so I said I wanted to read for Neelix, which was much more amusing to me. I tested for the part but didn't get, never knowing who else was up for it.

E: I read for Neelix first, then they asked me to try The Doctor. So we were being juggled again.

R: I'll never forget how, right after I booked the role of The Doctor, I was in discussion to play two gangster brothers in the film *The Phantom*. I knew I wouldn't have time to do both parts because of *Voyager*'s

shooting schedule. I wanted to go to the producers with a solution, so I said, "Why not have Ethan Phillips for the larger role?" That was when I learned you couldn't do it because you had just signed on to a new *Star Trek* show. Wait a minute! Ethan's on that? *I'm* on that!

E: That's just one example of how generous a friend you've always been. So even though neither of us were cast in that movie, we got to hang out for seven years!

R: There were a lot of fun people in that *Voyager* cast, but you were always the best joke teller. Every day, somehow, you had a new one.

E: But then you did that thing where you would try to "fix" my jokes. You'd switch a word and intentionally ruin it. It drove me nuts!

R: Maybe I did it to balance out how Neelix always got on The Doctor's nerves. But the truth is, off set and off stage, we're not like that too much. I think we're more warm, more supportive of each other than our characters ever were. Whenever I've gone through a hard time, you've been there for me.

E: Yes, but don't tell too many people that. It's more fun if they think we're lobbing light insults at each other all day. So much fun. I have to say, though, that time and time again, *Star Trek* proves itself to be unlike anything else. It can be such a catalyst for bonding between people. I've known people who have met through a shared love of *Star Trek*, then you see them again years later and they have three kids. It's extraordinary.

R: *Star Trek*, as the hopeful entertainment that it is, tends to attract an optimistic and positive audience. It becomes a shorthand for people when they meet for the first time. When fans meet other fans and have *Star Trek* in common, they can leap beyond typical icebreakers to form a friendship. At its best it jumps across all age groups and ethnicities. It's really about shared ideas.

E: I was watching the news the other day, and they were talking about some technological advancement, and one of the reporters joked that it wasn't quite perfect. He said, "We're not quite at *Star Trek*," and I'll tell ya it jolted me out of my seat a little bit. We were a part of that, Bob!

R: It was an incredible time. A dream, really. And though we do still get to be on stage together from time to time at *Star Trek* conventions and other appearances, I would love to work with you again some time, Ethan.

E: Back atcha. Hey, that reminds me, what do you get when you cross an alligator, a bowl of chili, and a race car driver?

R: Computer, end program.

Jordan: Robb, my *Star Trek* friend, it's so great to see you, and I am thrilled to chew the gagh with you once again about our beloved franchise, and its relationships.

Robb: That conversation between Neelix and The Doctor . . . I mean Ethan Phillips and Robert Picardo prove my point that *Star Trek* friends are the very best friends anyone can have. Even if they're a hologram.

J: I wish, somehow, there was a way to get all my *Star Trek* friends into one episode. I know it's a little silly, but I do consider these characters to be my friends, too. And I think that's because *they* are friends with one another, not merely companions in adventure and exploration but friends. That comes off the screen, and I've come to realize that this is why you can often make a fast and tight bond with someone else when you learn that they, too, are a *Star Trek* fan. Whether it's spending time at a convention or just hitting *like* on a funny social media post, when you clock that someone else "speaks" Spock, you've jumped the line a little on creating a friendship. Especially if you are Mr. Atoz–aged, like we are, and remember a time when liking *Star Trek* was something you kept quiet.

R: Speak for yourself. I like to think I'm as in my prime as Pike in everything but the Starbase 11 scenes in "The Menagerie" episodes. Yeah, that's a TOS reference, and I stand by it. I first discovered *Star Trek* when it was just The Original Series reruns after school and on weekends. Sometimes the whole family would watch it together, but when I would go to school, I would never talk about it.

J: Same for me. TOS came on late nights, and I would watch on a small TV in our guest room. If it was an episode like "The Alternative Factor" I'd fall asleep before the end. It took me years until I learned what happened to poor Lazarus. *The Next Generation*, since it was in syndication, aired on the weekends in the Philadelphia market, which is often where I would be when visiting my grandparents. I was discouraged from disappearing for too long to watch television on a tiny set in the kitchen, but I was given dispensation for *Star Trek*. I will never forget seeing Tasha Yar die in TNG season one's "Skin of Evil" and racing back, shocked, to report the news to my grandfather. "Don't vorry," he said in his thick, Russian Jewish accent. "She vill be back next veek!" It was the only time in his entire life he was wrong.

R: You had to wait for season three's "Yesterday's Enterprise"! This is why I love connecting with someone like you, my *Star Trek* friend! There are very few people I can make laugh by just whispering "Gorgon." I was very young, but I distinctly remember seeing *Star Trek: The Motion Picture* in a theater with my aunt, uncle, and cousin. It was overwhelming to see something that I knew from television transferred to the screen. I didn't quite understand it one hundred percent, but I

remember having no one my age to talk with about it when I got back to school.

J: It really is great when you meet someone else who is as enthralled by the totality of the franchise as you are. I mean, it's also exciting to welcome new fans and watch their journey as they join us as part of the collective. "I just met Worf!" is one of the greatest texts you'll ever receive. But when you know someone else has put in the time and watched all eight hundred episodes, and maybe read some of the novels or comics, it isn't only in-jokes about plomeek soup or Wesley's sweaters. There's usually a shared value system. Most of the hardcore fans maintain an intellectual curiosity, a generosity of spirit, and a warmth. Not to say we don't disagree, but usually it's done with respect, and, more importantly, when it's a disagreement about the show—like whether Scotty or Geordi La Forge is the better engineer—it's done with some playfulness.

R: First of all, I will not have you disparage Wesley's sartorial choices. And second, the best engineer is B'Elanna Torres, obviously. I can't believe I am even talking to you. Beam me outta here!

J: There it is. Well, before we start duking it out like Kirk and the Gorn, do you have an all-time favorite on-screen *Star Trek* friendship?

R: I will always stan Kirk and Spock's friendship the most. I know that's not the hottest take in the quadrant, but nothing short of an agony booth is going to change my mind in this or any mirror universe.

J: You can't beat a classic! And of course that's my pick, too. They have a true friendship and recognize how they complement

each other. Usually when I think about the two of them it's, "Oh, Kirk needs Spock so much," which of course he does, but I think Spock also sees things in Kirk that he has actively trained himself to suppress. They each have traits the other simply can never have. Kirk knows that without Spock to keep him in check, he'll default into just being a man of action and wind up using that Kirk Chop too much.

R: I've been thinking about this a lot, maybe even overthinking, as is my wont, about when Spock sacrifices himself to save the *Enterprise* in *The Wrath of Khan*. And they do the hand thing . . .

J: Wait, you are going to make me cry! You can't just surprise me with that!

R: Sorry not sorry. Just pretend I'm Sybok and share your pain with me. What I'm trying to say is that it's exactly when we're sharing those final moments with Kirk and Spock that I think we all realize that that declaration of friendship had never been as deeply articulated before. For example, when Spock returns to the *Enterprise* in *The Motion*

Picture, Kirk is like, "You're back! Great! Please sit down!" And as much as we know that Spock is glad to see him, he has his own reasons to be there. And half-Vulcan that he is, he never allows himself the luxury to share, let alone express, his joy in being reunited.

J: The closest we would have seen them express anything like that would have been at the end of TOS season two's "Amok Time," when Spock thinks he's killed Kirk, and then Kirk's like, "Aha! Fooled you!" which is played for laughs. That kind of posturing, that ribbing back and forth goes all the way back to that first Tridimensional chess game from season one's "Where No Man Has Gone Before," and it's completely dropped when we get to *The Wrath of Khan*. There's an openness which goes both ways, like when Kirk takes command, that scene in Spock's quarters with the awesome sequined IDIC mural, Spock stops him and says, "Jim . . . I am a Vulcan. I have no ego to bruise." It's very different from the last episode of season one's "Operation: Annihilate!," when Kirk's brother is killed, and Spock clumsily tries to extend condolences. Kirk just interrupts him with a, "Yes, yes," and finds an excuse to spring to action just to let Spock off the hook.

R: And unless toxic masculinity somehow makes its way into the twenty-third century, I don't think any of this is because they're suffering under the weight of

society telling them they shouldn't express how they feel. Spock's a Vulcan! Captains and their Vulcans—they're two great tastes that taste great together, especially from a mess hall replicator. Just look at the dynamic between Janeway and Tuvok on *Voyager*.

J: Tuvok is a rock for Janeway. She's known him for twenty years across three different starships, yet despite their history, he's not technically her number one on *Voyager*. She chooses Chakotay, which is admittedly somewhat politically smart as it unites the Starfleet and the Maquis crews. But since Tuvok's a Vulcan, Janeway knew that, to say it again, he'd have no ego to bruise. So despite not being Janeway's second in command, Tuvok is still the one the Captain turns to when she needs a reality check. He's always all business, and he's always loyal. Remember the end of the VOY season seven episode "Repression"? When his mind is controlled by the crazed vedek who wants to kill all the Maquis members. It's that bond, that friendship with Captain Janeway, that breaks the spell and gets him back in control. They're able to laugh about it later while watching *Attack of the Lobster People*.

R: And like Kirk would with Spock, Janeway enjoyed making jokes with Tuvok. Vulcans are nature's perfect straight men. And by that, I mean a deadpan partner to a comic foil not, like, a *straight* man. Not that there's anything wrong with that. My point is that, even if he doesn't demonstrably join in on the joke, he understands it and appreciates it. Similarly, he understands and appreciates everything that makes Janeway as good a captain as she is a friend. As determined as she may be to get the crew home, she makes a genuine effort to get to know them as individuals. And the person she knows the best, at least at the start, is Tuvok.

J: It's different from how Captain Archer and T'Pol started on the *Enterprise*. Here's a great example of two people, let's face it, not liking one another too much, then growing to become true friends.

R: All the other captains have at least a hundred years of interstellar and interspecies history behind them to learn from. Not only is Archer starting on the *Enterprise* without that, so much of his environment

is rooted in a fundamental unease and distrust of Vulcans. And let's face it, neither T'Pol nor her Vulcan colleagues are, shall we say, particularly impressed with humans. As humans, I think we can see that though some of that is justified, some of it's just plain old Vulcan condescension.

J: A lot of the relationships in *Star Trek* begin as, "Oh, they're just work friends," but then through shared adversity or just familiarity this blossoms into true, lasting friendship. But with Archer and T'Pol,

they're not even work friends at first. We're just hoping they get to that. It would be easy for Archer just to think of her as a babysitter, and for her to think these smelly people are beneath her. But they share a hierarchical order of being on a starship, and this keeps them both in place long enough for them to realize, "Aha! Maybe I had some blinders on here." For T'Pol it's almost like, "Oh, I'm forty-five years old and my new boss is twenty-five." Do you let that bother you, or do you work with it and hopefully realize, "Well, my twenty-five-year-old boss is really sharp, and also recognizes what I can contribute."

R: I like to think of T'Pol as someone from the corporate office who's typically thinking about the big picture, and now she's transferred down to the local branch. So she's doing a lot of internal realignment to focus specifically on how things are really working rather than how they *should* be working. Or not. For the first time in her life, she's got to be in close and inescapable contact with actual humans. Another thing I noticed, between Archer and T'Pol, is that when he teases her, it's always for an audience. Maybe it's Trip, maybe it's just for Porthos. But when she

zings him back, it's just for *her*. She is her own audience. And I find that charming.

J: Picard never had a Vulcan, but he did have a Soong-type android.

R: And not just any Soong-type android—the only one. Well, if you don't count Lore and B4, but that's another story. My point is that in addition to Picard being his captain, he was also Data's friend. Look no further than how he tried to fight for his civil rights in TNG season two's "The Measure of a Man." And the feeling was mutual, too, as Data sacrificed himself to save Picard's life at the end of *Nemesis*. And of course it's their bond—their friendship—that's the catalyst for everything that happens in *Star Trek: Picard*. Picard wants to honor Data, his legacy, and their friendship, so does what he can to help Soji and Dahj, all of which gives Picard the emotional closure he's been looking for. It's really interesting to me, too, that, throughout TNG, Data wanted to be more human. But it was Picard, first as Locutus of Borg, and then in his golem body, who became less "technically" human and more tech.

J: This is all so different from Major Kira and Commander, later Captain, Sisko on *Deep Space Nine*. They definitely lock horns at first, mostly because Kira wants Bajoran independence and Sisko doesn't want to be there at all. There isn't the level of good-natured zinging between the two of them, like we've mentioned with the others. Which is understandable because Sisko's dealing with the death of his wife and knowing he'll have to balance being a good leader with being a good father, and Kira is still dealing with her PTSD from her time fighting against the Cardassian occupation of Bajor. The way their friendship develops has unusual twists and turns, especially because they must deal with the fact that, to Kira, her boss is literally a holy man—the Emissary.

R: You and I have gotten to work with some of our pop-culture heroes. These are people we put on a very tall pedestal because we respect their lives and work so much. I don't want to speak for you, but even though I'm often calm on the surface, I'm completely fanboying on the inside. It usually goes really well, but every once in a while you find yourself in a situation in which you feel let down by your hero. How do you reconcile their humanity with the image you've created? If you can truly get to know them, then there's nuance and forgiveness as there would be in any relationship. But if it's only hero worship, if you've no real interest in getting to know the person, it's easy to let a negative situation disintegrate you into oblivion. To be a good first officer, and to be a good friend, you *have* to push back from time to time. I think that all of Kira's decisions come from a good, well-intended place. She was never a

fighter just to fight, she was always ready to justify her actions. Kira was able to find a human balance—even though she was Bajoran—and to see Sisko as a multifaceted being rather than just one thing.

J: We learn, for example, in DS9 season five's "The Darkness and the Light" and season six's "Wrongs Darker Than Death or Night" that Kira is dealing with some, well . . . it's in the episode titles—darkness. But the way she emerged from those horrors differentiates her attitude from that of what's maybe the most *proudly* loyal first officer, Commander Riker. No one loves their captain quite like Riker does—and who can blame him? Wouldn't you be almost embarrassingly loyal to someone like Captain Picard?! The bond those two had . . . just thinking about it . . . excuse me, there may be something in my eye.

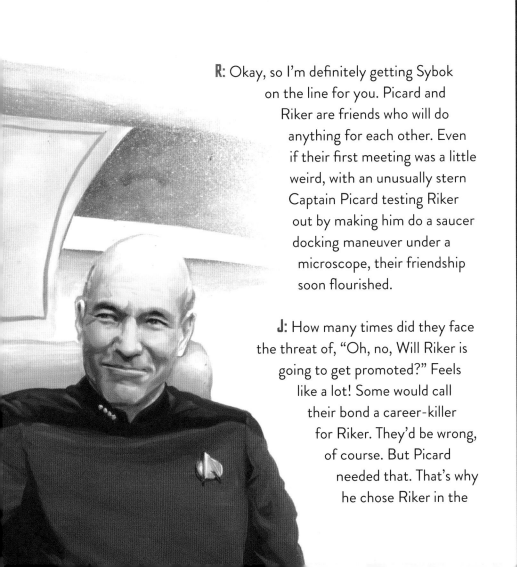

R: Okay, so I'm definitely getting Sybok on the line for you. Picard and Riker are friends who will do anything for each other. Even if their first meeting was a little weird, with an unusually stern Captain Picard testing Riker out by making him do a saucer docking maneuver under a microscope, their friendship soon flourished.

J: How many times did they face the threat of, "Oh, no, Will Riker is going to get promoted?" Feels like a lot! Some would call their bond a career-killer for Riker. They'd be wrong, of course. But Picard needed that. That's why he chose Riker in the

first place, because he stood up to Captain DeSoto on the *U.S.S. Hood* at Altair III and kept him out of harm's way. And he knew he could give Riker the absolute worst jobs ever and trust him to do them, like making him be the prosecutor in "The Measure of a Man" to force him to prove to the best of his ability that Data lacked sentience. That's quite an ask! But they both knew the only way to save their friend was to not communicator-it-in, they had to come correct. Not unlike Kirk fighting Spock in "Amok Time," in a weird way.

R: Wait, does this make Bruce Maddox the T'Pau or Stonn?

J: I'm sorry, the thinner atmosphere surrounding that analogy requires a tri-ox compound shot if we're to continue. But the writers knew they had something good there. There are a few episodes where Riker must go up against Picard. Most famously, of course, the end of TNG season three's "The Best of Both Worlds."

R: I can still hear those trumpets blaring as the "To Be Continued . . ." came on the screen. And as someone who chose to spend their summers sitting in air-cooled comfort watching television and reading rather than having to go outside to play sports (the word still gets stuck in my

throat), waiting for the summer of 1990 to end for the next episode to air was a particularly difficult season to get through. And don't forget about TNG season seven's "The Pegasus," when Riker is ordered to keep the prototype cloaking device a secret from Picard—you can see it destroying him. It didn't do much for my anxiety levels, either.

J: That whole episode stresses me out. I can watch anything, but I can't bear to see Riker lie to our beloved captain. It wasn't his fault, though! I really do love the way the two of them regularly know what the other is thinking, though, like the ending of TNG season two's "A Matter of Honor," and Riker's on the Klingon ship. Neither of them quite knows how that standoff will work itself out, but they trust each other enough to let it happen.

R: For that, the best is TNG season six's "Rascals," when the aged-down Picard, or as I like to call him, "'Lil' J-L" must pretend to be Riker's son. They both know exactly what to do and how to play it, but Riker is just loving every moment of it. He knows he's going to be retelling this for years and years, because "Oh boy, this is going to make for a funny story." Riker is one of the very few people who can crack a joke at Picard. And like any good friend, he knows exactly when to do it.

J: They can tell what each other is thinking by just a glance, and sometimes a friendship can really be solidified by just a glance. How about the TOS OG master glancers, Sulu and Chekhov? These guys both get a little more time to shine in the movies, where there's more emphasis on the whole crew as a team. But in the series, more often than not, all we get to see is a glimpse between them.

R: It's a glimpse that says, "Dude, as soon as we get off work, we're gonna have some Saurian brandy and talk about all of this mess going on behind us." Sulu and Chekov are the ones who

are side by side, literally with a front seat to all the action. But other than a small bit of dialogue here and there, they keep pretty quiet on the bridge. It's like they are in class and aren't supposed to talk, but they're totally passing notes.

J: Or in Chekov's case, complaining. Like in TOS season two's "The Deadly Years" where he's groaning about the medical tests because he's the only one who isn't aging.

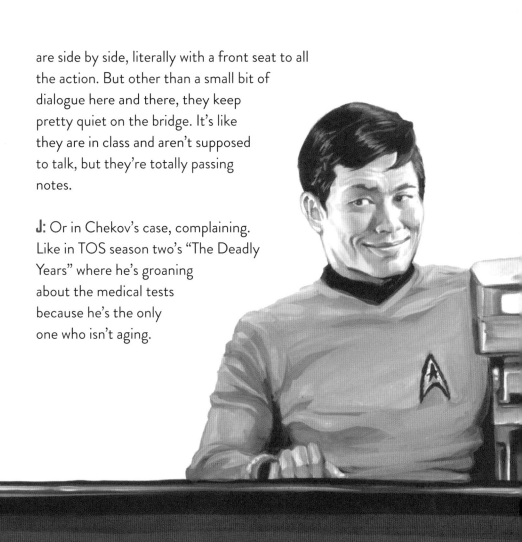

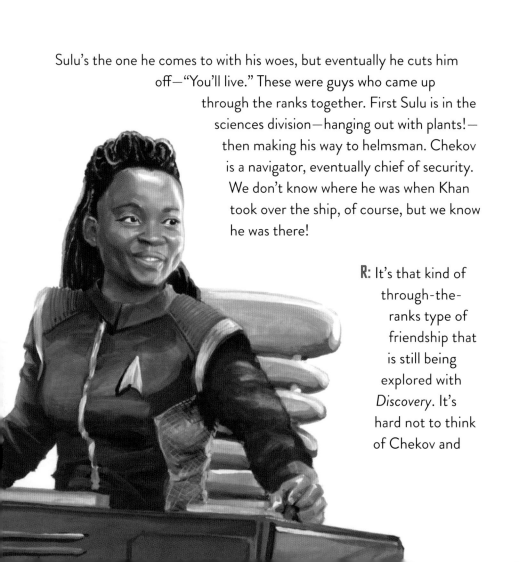

Sulu's the one he comes to with his woes, but eventually he cuts him off—"You'll live." These were guys who came up through the ranks together. First Sulu is in the sciences division—hanging out with plants!— then making his way to helmsman. Chekov is a navigator, eventually chief of security. We don't know where he was when Khan took over the ship, of course, but we know he was there!

R: It's that kind of through-the-ranks type of friendship that is still being explored with *Discovery*. It's hard not to think of Chekov and

Sulu when you see Owosekun and Detmer, who also share the very particular kind of friendship that comes from sitting in those same front-of-the-class seats. *Discovery* made a choice to be less bridge-focused than other shows, but viewers, and the characters themselves, are noticing tried-and-true patterns. I think these two understand that when they are "on the clock" they have specific jobs to do. But when you are friends as well as coworkers, you just look at each other and it's, "Oh, yeah, in six hours we're going to happy hour to talk about this!" It's like if you and I are at a convention and something weird happens, we'll give each other a look, then the texts are at warp speed.

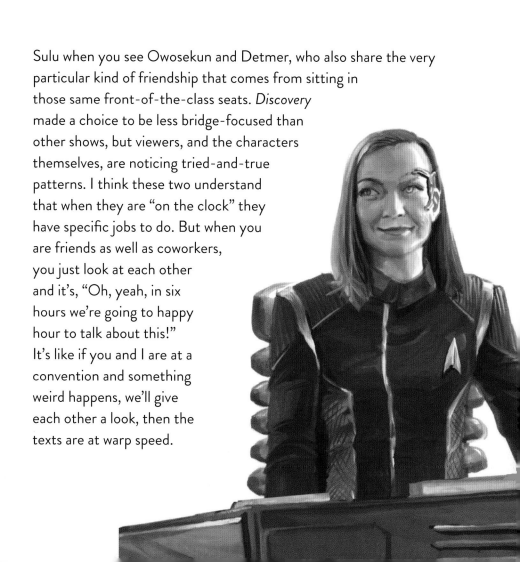

J: There's a lot that can be said with a look. Not just reaction-shot comedy, but "I've got your back," too. It's interesting, because another "through the ranks" friendship is Geordi La Forge and Data. Their hearts—one muscle, the other

mechanical—are on their sleeves. Data is a character that affects everyone, much like Spock. He's the ultimate outsider that everyone relies on. Geordi as a tech person is obviously drawn to Data as a perfect machine—no matter how much he tinkers, he'll never create his own positronic brain. But to Data, Geordi is an aspirational figure.

Data's programming urges him to try and be more human, so Geordi is an end goal. From this unusual foundation they become true friends.

R: I think Data also sees Geordi as someone who was not necessarily limited by the circumstances of his birth. This has to be so encouraging to Data, as someone who is struggling to become human, and to understand what it means to be human. Whenever Data goofs, like growing a Riker beard or calling people "lunkhead," Geordi is there to reel him in, but he also stays supportive.

J: I think more than any other character, Data was eager to talk about the importance of friendship. Of course, he had an interesting

take on it. Counselor Troi quoted him in TNG season five's "Time's Arrow" as saying, "As I experience certain sensory input patterns, my mental pathways become accustomed to them. The inputs eventually are anticipated and even missed when absent." But that openness just endeared him to the others even more. There's a tiny moment I love in the movie *Insurrection*. The Admiral has reported on Data's alleged rogue activity, but the whole gang knows *no way*—there's an explanation. They don't for a minute distrust Data. And even after Captain Picard and Worf have to essentially kidnap Data with their shuttle, we cut to Geordi and he's just *at work*. Immediately. He's in the neural net, poking around. Whatever happened here, I trust my friend.

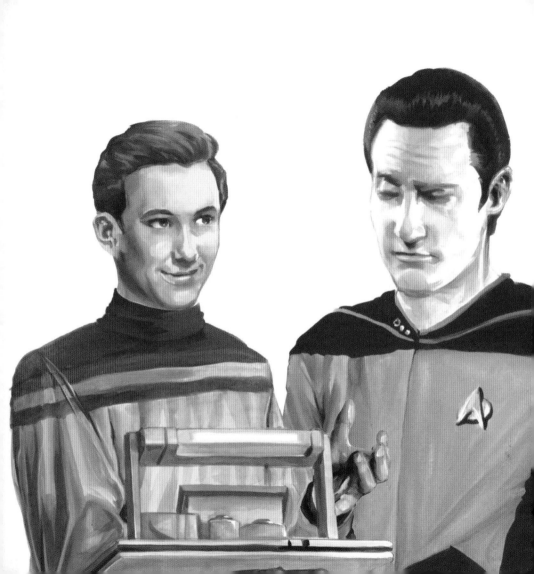

R: Not to go all yin-yang here (or maybe Lokai-Bele), but I think Data's friendship with Geordi is beautifully balanced by his friendship with Wesley Crusher. Wesley's thirteen years old when we meet him and, I would imagine, looking at the rest of the crew, more or less, in much of the same way that Data is. He is seeing them as older, more mature, and more settled in their skins, but he also knows he's considerably smarter than a lot of them. I don't mean to say he's cocky or arrogant, but despite his physical and emotional immaturity, he's a genius and he knows it. So, he and the most evolved artificial intelligence in the galaxy bond over the fact that they're kindred spirits in a way. It's like Data's in ninth grade and Wesley's in seventh. I always appreciated that unlike a lot of people on the *Enterprise-D,* Data wanted to be a mentor for Wesley but oftentimes bit off more than he could chew. So they ended up just being really good friends, usually dorking around about the long-range sensors or reversing polarity or the other sorts of things two young chaps talk about.

J: And since Data had "no ego to bruise" he would gladly take social advice from anyone, even from a kid. It's really a testament to the show. I mean, could you imagine how easily this could have slipped into pure cheese? A kid

and his robo-pal zipping around on a spaceship?! A robo-pal who won't use contractions, no less. But they pull it off. *Star Trek* is so good!

R: *Star Trek* is so good! And it's great fun to compare Wesley and Data's teen development against the only real analogue, *Deep Space Nine*'s Jake Sisko and Nog. I've always viewed them like when your parents drag you to some gathering and there's only one other kid your age. You're stuck with each other, so you might as well be friends and wallow in your teen angst together. It's great to see them start off as scamps messing around with self-sealing stem bolts, then watch as they blossom into interesting, three-dimensional people with their own personalities and wants.

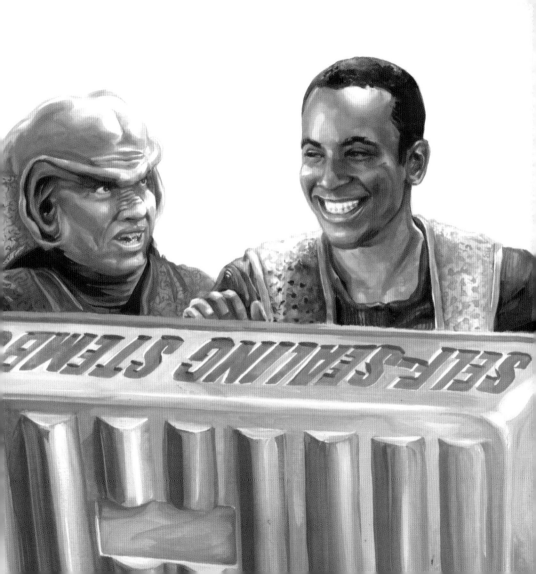

J: Jake is the first reporter we meet in *Star Trek*. You'd think he'd want to follow his father into adventure and command in Starfleet, but he takes a much different approach. And Nog, as an observer, proves himself and becomes the first Ferengi in Starfleet. They each went in a direction the other was expected to go in, but they each supported one another.

R: Right, Jake never said to Nog, "Blech, Starfleet? Why would you want that?" He was just, "Great, if that's what you want then you should go for it." It's not a friendship that's in the spotlight too much, but when it is, you really get a sense of what normal life looks like in this environment. Yes, they had their schemes. Their yamok-sauce-drenched schemes. And when Jake wanted his dad to go on dates, Nog would pitch in on the effort. But they were kids being kids, and kids who were learning how to navigate the world, or in this case worlds, on their own and together. Kids these days, huh?

J: Kids and their wacky clothes. People always make fun of Wesley's clothes, but I think Jake's were wackier.

R: Oh please, you sound like an old man shaking his fist at a nebula. Teenagers try on lots of different fashions and personalities to try to figure out who they are. Jake had tons of choices, but poor Wesley had, what, three outfits before he zoomed off with The Traveler? I mean, come on! He never even got to go through a goth phase!

J: Well, Jake *did* have access to a certain Cardassian tailor. But I don't want to talk about him yet, he's special. I want to go to the Delta Quadrant with my boys Tom Paris and Harry Kim. Do you think their bro-y booster engines were boosted a bit too much with all their chit-chat about the Delaney sisters?

R: Listen, I'm never one to apologize for straight white guys, but no, I don't think so. Tom does start out as a bit of a typical alpha male, with Harry just sort of going along with it (as, let's face it, lots of guys do). I think it speaks volumes about their relationship that they first met in a bar. Quark's, in fact, which delights me as I'm a sucker for a good crossover. You can tell that Tom's a good guy by the way he helps out Harry so he doesn't get swindled by Quark. To me, they're like two college guys, one just graduated, one hanging around campus after doing some not-so-hard time, they are having beers together, then they go off into outer space, cracking jokes but also definitely having each other's backs.

J: And, in space, "alpha" is relative. They do come from different backgrounds. Harry's a down-to-earth (no pun intended) recent grad who misses his mom and fully embraces his nerdy side, while Tom is a rich kid rebelling against his admiral father. All he wants is to detail muscle cars and play pool in holodeck France. At first he's like, "Oh, you're gonna put me in

a penal colony? So what?" But once he's on *Voyager*, and he gets closer to friends like Harry, he drops that bravado and realizes that actions have repercussions, that stakes are real.

R: Like all good characters and, let's face it, people, growth makes him great. People rarely stay exactly the same as they were when they were in high school or college. You gain experience and really settle into who you are as a person. And as you grow, friends come and go, and friendships grow, too. And it's the growth that I find interesting when compared to *Star Trek*'s other great "bromance," if you will, because I will, between Chief O'Brien and Dr. Bashir. These guys have a solid few

years on Harry and Tom. They have more professional and personal experience, more emotional maturity, and have both made conscious, intentional choices to be where they are.

J: Dr. Bashir and Chief O'Brien are great because *Deep Space Nine* is all about the broad spectrum of characters and their intricate relationships, and then you get to these two and it's like, "Behold: normalcy!" Their friendship, more than any other, is one that can be dropped from our timeframe into the future. They are fun guys that work together and love to grab a drink, throw darts, and cavort in a holosuite telling tall tales. It's the urtext for the "bromance," which became a big deal in movies in the early 2000s. And it was all so upfront, like when Keiko has the second baby and the Chief can't come out to play. Even though these are adult, intelligent men, they are both pouty. It's cute.

R: Yes, they are. Wait, what? I mean that sort of relationship seems to have organically emerged from the characters. O'Brien is a noncommissioned

officer and speaks with his brogue. Dr. Bashir, though younger, has this elegant look and manner of speaking. Who needs a period drama about class struggles when you can spend an hour with Bashir and O'Brien?

J: I mean, for us dorks watching, operating the transporter is the coolest and most *Star Trek* thing in the world. But in reality, O'Brien's first gig is as a doorman! He's the doorman of *Star Trek*! But think about it, when you're the doorman, you get to know everyone, and everyone loves you! Then he worked his way up. You see his wedding on TNG season four's "Data's Day," which is meant to be a plot-light episode about the mundane aspects of *Enterprise*-living, so it has a lot about this most relatable character. And of course, Dr. Bashir comes to Deep Space Nine specifically looking for adventures, so it's interesting that aside from his amorous endeavors, he's most drawn to O'Brien!

R: Well, it's not just O'Brien, of course. Jordan, hold on to your hems, because it's time. It's time to talk about Garak.

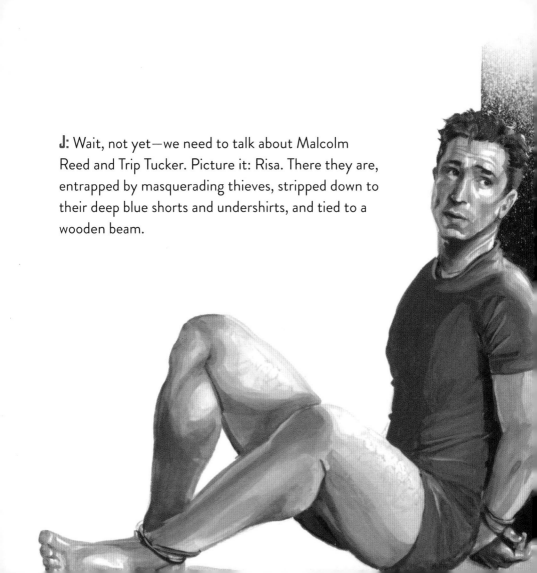

J: Wait, not yet—we need to talk about Malcolm Reed and Trip Tucker. Picture it: Risa. There they are, entrapped by masquerading thieves, stripped down to their deep blue shorts and undershirts, and tied to a wooden beam.

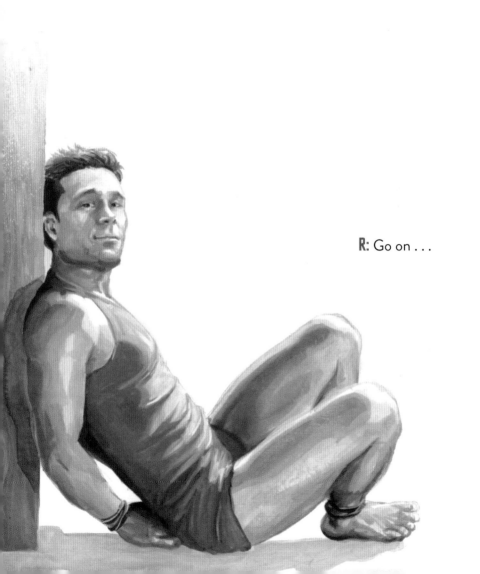

R: Go on . . .

J: Well, it makes for a good story. Trip is one of those "you gotta love him" characters, and so everyone does. He's an open book. Come to movie night and hang out. But Malcolm is so mercurial—there's a whole episode devoted to discovering he likes pineapples. So there's an "opposites attract" element here.

R: It doesn't diminish their friendship to say Trip is everyone's friend. Malcolm sees in Trip something he wishes he could be. Maybe it's an older brother/younger brother dynamic? The younger one wants to stand on his own two feet but still looks up for a little guidance. There's the great ENT season one episode "Shuttlepod One," where they are stuck together, it really defines and cements their relationship.

J: Which is a great callback to "The Galileo Seven" from TOS, one of the great bonding episodes. But we've been talking a lot about dudes, bros, pals, and homies. *Star Trek* will, eventually, feature great relationships between women. You can see the roots of this in TNG, especially between Dr. Crusher and Counselor Troi.

R: Two of my favorite characters. I . . . I have a lot of favorite characters. But to be honest, Jordan, I don't think you, as a straight cisgender man, and I, a platinum-card-carrying, Kinsey 6, cisgendered man, are the best candidates to talk about female friendships. And that's why we've invited our good friend, astrophysicist and *Star Trek* science consultant, Dr. Erin Macdonald into the conversation. Hi, Erin!

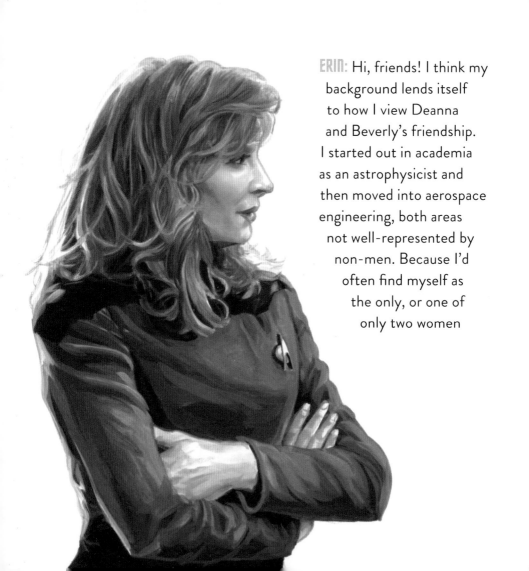

ERIN: Hi, friends! I think my
background lends itself
to how I view Deanna
and Beverly's friendship.
I started out in academia
as an astrophysicist and
then moved into aerospace
engineering, both areas
not well-represented by
non-men. Because I'd
often find myself as
the only, or one of
only two women

in a department or office, I'd
form a unique bond with
the other few non-men.
Though we may not have
necessarily been friends, our
shared unique professional
experience brought us closer
together. Sometimes these
friendships last after a
change in professions, and
sometimes they don't, but
that ending cannot diminish
the importance of having
someone at your side in
a sometimes difficult
and uncompromising
environment. Beverly
and Deanna's

friendship really reminds me of those relationships, in the best ways. One of my favorite scenes between Beverly and Deanna, and what reminds me most of my own relationships with other women, is from TNG season four episode "The Loss," in which Deanna temporarily (thankfully!) loses her empathetic abilities. Though she initially copes with her loss by just brushing it off, Beverly knows it has greater impact than Deanna is letting on (as many of us do). It's up to her friend—not a colleague, not a doctor, but her friend—to gently have the hard conversation with her, poignantly asking, "If you were anyone else, you know the first thing I'd do? I'd send you to Counsellor Troi." It's a wonderful episode, but it's in this moment that we really get to see not only the professional respect for one another but, by highlighting their similarities as well as their differences, their personal bond as well.

R: I think most of the scenes between the two of them pass the Bechdel test, too. There's a brief, seconds-long scene in TNG season six episode "Chain of Command" in which you can tell it pains Beverly to not be

able to talk to Deanna about what's going on. And Deanna shares that pain, knowing that her friend is struggling with not only the thought of going into a dangerous situation but also the fact that she cannot do anything to ease her burden. And maybe it's because she's a woman, as well as a professional counselor, but Deanna knows that sometimes when people tell you things it's not so you can fix the problem, it's just that you listen. I've always assumed that this brief exchange was a signal to the audience that these two strong, professional, brilliant women were friends who shared a lot more than we ever got to see.

J: I do like that both Counselor Troi and Dr. Crusher, who are outstanding characters with plenty of heroic moments throughout the series, are both healers. Friendship can contain many hard-to-explain qualities. And much like every atom in our universe has, at its center, a perplexing thrum of quantum particles we are unable to truly understand, one of the greatest friendships in *Star Trek* is the curious one between Dr. Julian Subatoi Bashir and Elim Garak. Walk with me, Robb, to the replimat, and let's talk about it.

R: Happily! I mean, who wants off-the-rack when you can get a garment whose creases are as sharp as the designer's wit, and whose hemlines are as eye-raising as their turns of phrase?!

J: In the very first episode of DS9, we learn that Dr. Bashir has come to this distant outpost looking for adventure. And, as we'll learn later from his holosuite adventures, he has a penchant for espionage adventures. The very first scene of the first episode after the pilot, "Past Prologue," the good doctor is flagged down by a curious man looking for new friends, none other than Deep Space Nine's mysterious tailor, a Cardassian outcast named Garak. Though many on the station think he's been left behind as a spy, Dr. Bashir invites him for a mug of Tarkalean tea. Garak accepts, calls him a thoughtful young man, and lo, a friendship is born.

R: Their replimat chats are a highlight of the series for me. Google tells me there are ten canonical on-screen moments, and many forums have devoted thousands of words of fan and slash fiction to even more. I happily defer to them all on this issue. My personal favorite is DS9 season three's "Distant Voices," because Garak is just so eager to give Bashir a birthday present that he does it a few days early—a Cardassian

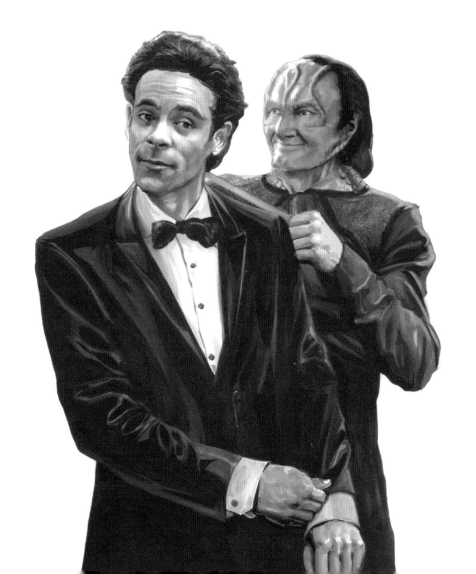

enigma holonovel with a bow on it. But Bashir is, in his own words, grumpy because he's about to turn thirty. You expect Garak to bark, "What are you complaining about?" but he doesn't. He lets his friend be grumpy. Sometimes a friend doesn't want suggestions, they just want someone to listen and be grumpy with.

J: And Bashir was always willing to let Garak be Garak. Bashir eats it up, and Garak is ready to spoon-feed it like it's I'danian spice pudding. Take their most famous exchange from DS9 season two's "The Wire," which begins to shed some light on Garak's time in the Obsidian Order. Bashir finally asks, "Of all the stories you told me, which ones were true

and which ones weren't?" "My dear doctor," Garak responds, "they're all true." Bashir thinks he's got him now and asks, "Even the lies?" and Garak says—

R: "Especially the lies." It's just perfect. Maybe it doesn't exactly make sense, but it's spellbinding. Let's face it, we all have our theories about who Garak is, where he's been, and where he's going. But that's on us. Garak is consistently and unapologetically himself and lets other people draw their own conclusions. He just doesn't care what other people think of him. He's just being himself and appreciates it when people, like Bashir, just accept him for who he is.

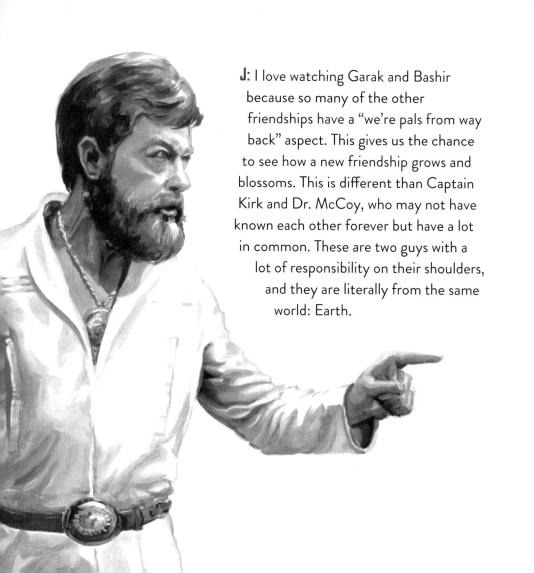

J: I love watching Garak and Bashir because so many of the other friendships have a "we're pals from way back" aspect. This gives us the chance to see how a new friendship grows and blossoms. This is different than Captain Kirk and Dr. McCoy, who may not have known each other forever but have a lot in common. These are two guys with a lot of responsibility on their shoulders, and they are literally from the same world: Earth.

Then you throw Spock in the mix. So much of the Kirk–Bones relationship is reacting to Spock. For a quiet, contemplative being, Spock creates a lot of commotion. When Kirk turns to Spock, who certainly is his closest friend, it's for logic. It's for the *how*. When Kirk turns to Bones, it's for moral guidance. It's for the *why*.

R: Think of the great image of the bearded Dr. McCoy with the medallion and tan suit and chest hair and belt buckle from *Star Trek: The Motion Picture*. Or, as I like to call him, "Disco Bones." He's griping and grousing about getting drafted back into service, but Kirk stops him mid-rant to say, "I need you. Dammit, Bones, I need you," then a pause.

"Badly." And he puts his hand out. Shoves it right in his mug. Bones takes it, Kirk pulls him in, and it's back to the adventure. It's a spectacular moment of love between friends.

J: And who knows exactly what awesome fun Bones was having out there in space, growing a beard, right? But when he hears his friend

needs him—not the Federation with warnings about a "thing"—but a friend, that's what brings him back. And will bring him back again and again. Bones is the friend who you can go a year or more without talking to, then you pick up a phone and you are instantly back where you were. It's like how Sisko calls on his former mentor, Dax, to Deep Space 9. It's as if he thinks, if I am stuck with this assignment that I don't

really want, I'm bringing in my "old man." Of course, now he's bringing in Jadzia Dax, who is a Curzon 2.0. Or an 8.0, I guess. All the captains are figures who have earned respect, and you don't really goof around too much in their presence, but none so much as Captain Sisko. Dax, however, could get away with speaking a little more freely, even zinging him. Like in the DS9 season four episode "Indiscretion," she kinda mocks him for his not-very-smooth reaction to Kasidy Yates saying she's moving to the station. Or the season six episode "The Reckoning." She's helping to decipher these Bajoran tablets and when they get to the part about the Emissary, a very touchy subject, she slips in, "You'll like this part, it's about you." No one else could say that.

R: Then there's the great moment from the season four episode "Rejoined." He lets her know—he lectures her—that he has to turn her back on her ex-lover Lenara, that every known Trill social code demands

it. But then he adds that whatever decision she makes, he'll back her all the way. And she says, "I've lived seven lifetimes, and I've never had a friend quite like you." I also love how the Sisko–Dax relationship has become, in recent times, something of a model of transgender acceptance. Whether it was meant to at the time or not. That's always been part of *Star Trek*, how, for example, neurodivergent people sometimes talk about Data, or even some of the more obvious racial metaphors in The Original Series. There's the meme from the second season episode "Blood Oath" where the Klingons say, "Curzon, my old friend," and she says, "It's Jadzia now," and without missing a beat it's, "Jadzia, my old friend!" It so succinctly says that when you're friends with someone, it's about who they are, not what's on the surface. And you accept changes. Likewise, Sisko and Dax's friendship remains strong regardless of whether or not he's a Starfleet officer or an emissary, or what body she's in.

J: Another friends-from-way-back duo that I love is Captain Archer and Trip Tucker. It's funny, because I barely know how to insert an isolinear chip, but I really fall for that "I'd love to share a Romulan Ale" with guys like O'Brien, Scotty, and Trip. I guess I have a bro-y dilithium crystal lit within in me somewhere. I think Captain Archer realizes palling around with Trip is one of the great perks of his job. He's got that Southern drawl, crooked smile, and he's picking out classics for movie night. All this puts people at ease, but he's also a bit of a brainiac. When the two of them are together they give off that *The Right Stuff* vibe of wanting to be first and wanting to break records, but they aren't jerks. Their interest in personal glory is still countermeasured by wanting to do something noble.

R: And since they've known one another for a decade before we meet them, there's a level of intimacy that can lead them to quickly lean into dangerous bits of derring-do. More so than, say, Kirk and Bones.

J: Of course, The Original Series has a century of familiarity with space exploration, so there's a refinement there. The cowboy element Trip and Archer share is also because they've been held back for so long by the Vulcans. And these are the types of people—goal-oriented straight white guys—who are not accustomed to that. That first mission in ENT season one's "Broken Bow" is only to drop the Klingon off and come right back. But then they got the greenlight to keep going and it was like, "Finally! Freedom!"

R: Their dynamic is a stark contrast to two other "old pals," Michael Burnham and Saru. Their still-evolving friendship has roots from before *Discovery*'s first episode. They both served aboard the Shenzhou, and both served under Phillipa Georgiou. Burnham was first officer and Saru was science officer, but there was some very obvious competition going on between them. And Saru, being a very by-the-book guy, did not take well to Burnham's initial maverick moves. It's been a long

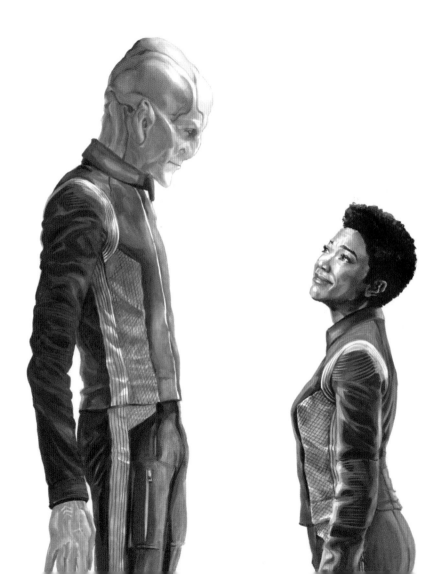

road, to use a *Star Trek* phrase, to get to where there isn't just trust and admiration between them but genuine friendship.

J: Which is why it feels so hard-won when they get there. Like when Saru sheds his threat ganglia during his varhar'ai, and we think he is dying—there's so little known about the Kelpians!—and she's right there with him to pick up his, um, gross, squibbly tendrils.

R: Are you besmirching the good name of Saru?

J: I love Saru! My wife and I named our cat Saru, which is perfect because when we first rescued her off the harsh streets of Queens, New York, she was a fraidy cat, just like we thought Saru was. But now, it's as if she herself has passed through the varhar'ai and is a fearsome warrior.

She may not shoot darts out of her neck, but her claws are sharp enough to keep us away sometimes. Anyway, I like the moment, at the end of season three, when Saru has to discipline Burnham, and she actually pushes him to do it. She's like, "I pulled a Michael Burnham here, and I have to face the consequences," and he's thinking, "Well, she did save the day, but she will hate me if I let her off the hook just because we are friends." It's a thick seven-layer hasperat of complexity that is rooted in friends having to sometimes deal with uncomfortable situations.

R: And that's because Saru knows her well enough to see it from her perspective. That's the hallmark of a true friendship. Like we see in *Picard* with Picard and Raffi. And what's so great about this is that while she is new to us in the audience, she's had years of experience with Picard, or J-L as she calls him, the whole time we have "been away," so to speak.

J: Raffi is the perfect audience surrogate. To some extent, she is there to represent "you haven't seen Picard for a bit, and time changes everyone. Don't worry, though, I'm here to fill you in." Longtime fans like us have been with Captain Picard since the mission to Farpoint Station all the way through Data's sacrifice. We feel like he's our friend! I needed a calming cup of Earl Grey tea—decaffeinated Earl Grey tea, apparently—to get over it at first.

R: It's always weird to meet your friend's friends. But you have to take the leap of faith (of the heart?) and think, "Well, any friend of J-L's is a friend of mine." There's always a bit of a probation period, though, when you aren't sure. Maybe because you worry you are going to be replaced. And, when you meet Raffi, it's like, wait, is she supposed to be a Riker 2.0? Which, of course, she's not. She's her own person. And then Riker shows up cooking pizza later in the series.

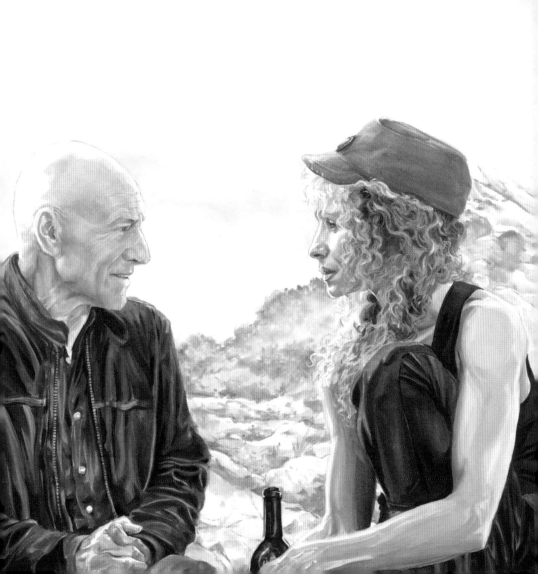

J: Robb, I'm gonna need to grab some tissues if we're talking about the group hug here.

R: We are. It's a sensational part of a sensational first season of *Picard*. Partially great fan service, certainly, but also it narratively shored up that friendships with these wonderful characters were just expanding not breaking apart. Picard, Riker, and Troi are more than friends, they're family. They're our friends and family.

J: We're specifically talking about friendships, not romances, but I'd like to break through that galactic barrier just for a moment and say something about Riker and Troi, especially in the context of friends-with-history. For almost all the time we saw them, Riker and Troi were not lovers, they were exes, and the most mature, supportive exes anywhere in the galaxy. An overused phrase in *Star Trek* fandom is

"Gene Roddenberry's vision," but this very "I'm OK, you're OK" vibe they had really imprinted on me when TNG launched. I was thirteen years old thinking, "Ah, yes, someday I will go on dates with women." Then, 930 years later, when that finally happened, I just admired the hell out of the way they were always rooting for one another, even after breaking up. Cheering one another to go on dates? Where else did you see that on television?

R: And there never was a "will they / won't they?"

J: Right. But then, of course, they did get married in the end. So ha! An unusual, unique friendship that doesn't fit a known pattern. Kind of like the concept of the frenemy.

R: With space frenemies like these, who needs friends?

J: The lack of oxygen really exaggerates everything, I think. Let's start at the top. With everyone's favorite frenemies, Spock and Bones. You say those two names and what image comes to mind for you?

R: I think of drinking orange juice right after brushing my teeth. Both great on their own, but when put together . . .

J: For me it's Spock in sick bay at the end of TOS season two's "Journey to Babel" and Bones going, "Shh!" Sometimes you just have to say, "Shh!" And then that smile. Bones and Spock love each other, that's for sure. It's more in Bones's nature to admit this, even if it's in its own irascible way. I am thinking of, "Shut up, Spock, we're rescuing you!" from season two's "The Immunity Syndrome." Classic stuff.

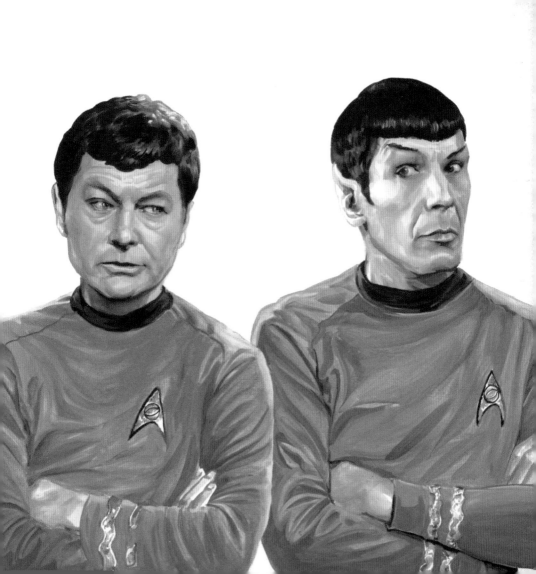

R: Bones and Spock are the textbook description of frenemies. What bonded them despite their differences was their mutual friendship for Jim Kirk. Even when they disagreed, it was always with Kirk's best interest at heart, just seeing it from a different perspective. That's the base of it, plus the fact that they see in one another something that they either want or they want to repress.

J: Forget three-dimensional chess, this just got into ten-dimensional psychology!

R: Was Bones really upset when Spock used him as a katra vessel before charging into the warp core chamber at the end of *The Wrath of Khan*? No. Was he annoyed? Yes, surely. He's a doctor, not a vessel!

J: He was thrilled! He was thrilled to help his pointy-eared, green-blooded buddy. But he was especially thrilled because he could hold this over Spock's head for years to come. Which he tried to do at the

beginning of *The Voyage Home*. But Bones would have volunteered to help Spock. He knows—everyone knows—that they are more than Starfleet. They're friends. But to bring it back down to a personal level, you're right, there's always the lens of their other friend, James Tiberius Kirk. Bones is never going to hit the full photon torpedo spread on Spock no matter how aggravated he is because he knows "that's Jim's boy." And even though Spock pretends to be cold-blooded, I think it goes both ways.

R: They know how far to push it. And they know how far to push their annoyance at the other in conversation with Kirk. When you are really close to someone, you can make delicate jokes to someone about their spouse. But only when the friendship—all the friendships—are on very solid ground.

J: And speaking of solids . . .

R: Oh, no!

J: You mean O-*do!* . . . and Quark, that is. Terok Nor's OG odd couple, the Constable and the Criminal. You can't find a more fractious relationship outside of a matter/antimatter intermix chamber. And of course, it's because they are, secretly, friends.

R: They are friends. Great friends, in fact, who give one another a reason to get out of bed (or out of a bucket) each day. Sisko is very wise to realize that Quark, even if he represents a kind of chaos, is necessary for the ecosystem of the space station. So Odo,

who likes things to be neat and tidy, has to learn to tolerate him. But he certainly grows to like him. Quark immediately likes Odo because he needs a challenge. It's not just about making a profit off him. It's about winning in increasingly clever ways, right under Odo's not-quite-human nose.

J: Their friendship has its roots in them both being outsiders. Quark is, let's face it, a parasite on the station whether it's run by the Cardassians or the Federation. And Odo has no background, he doesn't know where he's from. For the most part, their issues are about the space station. Sisko and Kira are worried about the development of Bajor and planetary treaties. They are dealing with wormhole prophets and Pah-wraiths while Odo is putting the screws to Quark over some hot shipments of kanar.

R: Remember the last episode, when Odo leaves with Kira for the Great Link, and he didn't say goodbye to anyone? Quark is the one who seeks him out. Quark chases Odo down—and Kira sees this and steps out of the way for them, as friends, to have their last moment together. Quark is like, "Don't you have anything to say to me?" Odo responds, "No!" Then Odo leaves, and Kira is about to say not to take it personally, and Quark is thrilled: "He loves me!"

J: Quark gave Odo purpose. He'd be bored otherwise. Quark kept him in shape, otherwise his detective muscles would atrophy. And how can you not like Quark? That smarmy charm, that glad hand, it's part of his Ferengi DNA. He makes you feel comfortable so he can fleece ya, it's like a natural instinct, as much as a Vulcan being logical. Plus, there's the satisfaction Quark has with testing someone he's friends with. It's nothing to pull a fast one on a stranger. But if you can, say, match wits with a family member you respect, that's something you can gloat about after. Maybe it's because it's all based in a bar, but I love how both Odo and Quark can get the rest of the gang to see it their way. Quark could rally Jadzia or the Chief, or whomever, to agree—yeah, Odo is a real stick in the mud. But Odo could also get any of them to roll their eyes when Quark was being a little extra Ferengi. And that's the audience, too, playing that game.

R: And they always accepted that neither would change. Odo would always be there to make things difficult for Quark, but Quark would always be a swindler. Either accept it or put him in the brig for the rest of his life. Quark really has no parallel in any other show. As comic relief, maybe it's Neelix, but if Quark is someone defined by the struggle with his own greed, Neelix is the poster boy for intergalactic selflessness.

J: Kindness and joviality, thy name is Neelix. Lo, let me slurp deeply from your pot of leola root stew! Neelix is someone I care very deeply about. I can fantasize all I want about being as heroic and handsome as Riker or as brilliant as Spock, but if I were plopped into *Star Trek*, I would be Neelix. And that's more than fine with me. And yet I also love The Doctor, so much. His crabapple ways bring me such joy. Put the two together, and you've got a great pair. The Doctor, of course, is one of those characters, like Spock, who touches everybody, and while they rely on him a great deal and he always pulls through, he's a bit of a pain in the butt.

It's not his fault, he's programmed that way. Everybody gets annoyed with him to a degree, but Neelix has the most tolerance. Because much like The Doctor is programmed as a healer, all Neelix wants to do is help, just as much as any of *Star Trek*'s physicians. He has no training to do so, but it's innate in his character. And Janeway, to her great credit, recognizes this and assigns him the position of morale officer. This may seem superfluous at first, in a desperate situation seventy thousand lightyears away, but it's actually vital.

R: Neelix and The Doctor are one of my favorite comedy teams in all of pop culture. But I think Neelix is also great paired with Tuvok, too, because you're right. Concerns about morale would be illogical to a Vulcan. And speaking of illogical, I think we need to take a moment to recognize one of the best personifications of illogic, and a great example of a *Star Trek* frenemy, Tuvix. He's a character that, at first, seems like nothing more than a punchline, but then quietly segues into one of the most stark and uneasy moral complications of the entire franchise.

J: I don't think either of us should be discussing what happened with Tuvix without a lawyer present. But I do love the Neelix and Tuvok relationship, because it's a further example of what we've been talking about. Tuvok is all Starfleet—very trained, goal-oriented, embedded on the Maquis ship for intelligence purposes, a genius at the tactical station. And then in floats Neelix, a garbage collector. And now they are both part of Captain Janeway's inner circle on this long-term, existential mission! Lucky for Neelix that Tuvok is a Vulcan, otherwise he might get pissed!

R: Quark had Odo to spar with, Neelix gets The Doctor *and* Tuvok. Things get real in the Delta Quadrant. And things get real beyond the boundaries of our mere four dimensions. I have a controversial frenemy situation I'd like to discuss.

J: Controversial or Quontroversial?

R: Your typographical puns amuse me. But, yes, I mean Q and Captain Picard. Though friendship may not be the right word.

J: We are traveling where no one has gone before on this one. Q and Picard are friends? The first thing Picard always says when he sees Q is, "Get off my ship!" And Picard loves everyone! I suppose, on an intellectual level, Picard has a certain respect for Q. He holds him in a place of wonder. But he fundamentally dislikes him because Q's default position is to be judgmental and cruel.

R: But I think because Picard does have such a humane core, he recognizes Q's potential to be great. A greatness that no other being could possess. Q is a trickster and a nemesis. But he knows Q isn't going to go away. Yes, these are not benign encounters—lives are at stake. Nevertheless, Picard does realize he has no choice but to play at Q's games. And when he does that, there's a weird kind of playfulness there. I guess Picard thinks, "If I must have an archnemesis, I'm glad it's someone with an intellect like Q." It isn't, you know, Armus or an army of Pakleds.

J: Q has all of spacetime, he can bother anyone. Yet he always comes back to Picard. And I think Picard likes that he can match wits. For all of Q's superiority, and his ability to destroy mankind like ants, he keeps losing, and that's why he desires friendship. Picard is the brilliant upperclassman, and Q looks up to him, even though Q has no age. Q needs to grow up, is what it is. Picard would forgive him for his past transgressions if he really made amends, because Picard is all about righteousness. But Q has to earn it. The raw materials are there. You are right! There is a friendship of sorts there.

R: I don't think a discussion about frenemies would be complete without talking about Paul Stamets and Jett Reno.

J: They get the spores moving, that's for sure. As super-genius engineers they obviously have a lot in common. And though he has his mycelial experimentations, she has her more traditional twenty-third century technology, but they're essentially grease monkeys. Grease tardigrades? Despite the newness of the friendship, it's a begrudging love at first sight. It's clear they would do anything for each other, and they only bombard each other with barbs because they recognize that the other has strong deflectors.

R: Reno probably acts this way around lots of people, but she only gets away with it with Stamets. And she's only fully understood by Stamets. There are friendships out there that are based on sarcasm.

Not antagonism, but a prickly energy. It's not something you have with everyone, but it's their common language.

J: It certainly makes for great theater. Like, if you happen to be down in engineering while they are lobbing mines at one another, you are in for a treat.

R: And it's great that these two are multidimensional characters who are friends because of their many shared experiences, talents, and circumstances, and not just because they both happen to be LGBT. Jett is able to authentically comfort Stamets on losing, or thinking he's lost, Hugh Culbert because she knows what it's like to lose a spouse. Grief, like compassion, is as universal as it is genderless.

J: Given how much they have in common, it's a lot more likely a friendship than, say, the one between Captain Picard and Guinan. First of all, she is a millennium older than he is. Secondly, there's

something about Guinan and her position on the *Enterprise* that really nails that Roddenberry utopianism. At the end of TNG season three's "Yesterday's Enterprise," Guinan calls the bridge. "Is everything alright up there?" And Picard and Riker are concerned—why is the bartender bothering us on duty? But they aren't upset. They take the question seriously. And that's because everyone on Picard's ship is treated with respect. Everyone has a right to contact anyone because it's understood this privilege won't be abused. Can some lowly schnook who works in the cafeteria at a big corporation just ping the CEO? No! It could never happen. But it happens here. I love that.

R: Guinan is living her life, mixing drinks, listening to people. And she's patient.

J: It's interesting because all of Picard's friendships are with colleagues that are at the peak of performance. Riker is so good of a first officer

that he's being offered command of his own starship. Dr. Crusher is a top physician. Data has no parallel in the galaxy. But then his other great friend tends bar. No class distinctions here.

R: I also love the fencing scene in TNG season five's "I, Borg." First, because they're fencing, which I thought was a great callback to Sulu, and second, because they're speaking not as captain and bartender but as friends. They can literally parry with each other in that moment. But also, since she's not restrained by whatever protocols would be on another Starfleet officer, she can speak to him differently. And he's out of uniform, so he's speaking to her as a friend. Then they don't agree! It's one of the only moments where you see Guinan get angry at Picard. He digs in on his side of the argument, and even though she has a galaxy of wisdom, she allows herself to see things his way. They are able to do this because, again, it is a true and deep friendship.

J: It's maybe even better that we only get glimpses. Less is more sometimes. Like Hoshi Sato and Phlox. Our Denobulan doctor is, in a way, everybody's mentor, but his bedside manner really shines through with Hoshi, who starts out on the *Enterprise* with some understandable reluctance. Hoshi's an extraordinarily well-rounded character, and Phlox, well, what can be said about him? He's a wonderful nut. Phlox, like T'Pol, is very helpful to these humans leaving their system for the first time, but if T'Pol is focused on the intrigue on the bridge, Phlox's stories are a little more personal. God forbid, if I'm ever diagnosed with a Tarkalean flu, I want Phlox to be the one to tell me, he's very caring.

R: The NX-01 doesn't have a ship's counselor, so Phlox fills that role, and he sees that Hoshi really needs a little help. She's really not thrilled about space battles, even if she is a genius language expert who knows she's the best person for this job.

J: Phlox steps in to get her acclimated and addresses her concerns on her own terms, through her strengths. He meets her where she lives and starts teaching her Denobulan. She already knows a thousand

languages, but now she's gonna know a thousand and one. But while this is happening, she's going to teach him a little about human beings. In the ENT season one episode "Dear Doctor," he's having dating woes, so this back and forth is helpful to them both.

R: It's a variation on what we saw on *Voyager* between The Doctor and Seven of Nine—the hologram teaching the cyborg about how to fit into human society.

J: *Star Trek*!

R: It's all just so good.

J: I like it. And I love Seven of Nine. Even an enlightened crew like you'll find on *Voyager* doesn't quite know what to make of her at first. The Doctor, being such an outsider, obviously has none of these concerns. So the next thing you know, they are singing "You Are My Sunshine" as a goal-oriented activity. It starts with designing dermal regenerators then leads to country tunes. The Doctor sees things in Seven not everyone else can, and I think it's because Lewis Zimmerman, bless him, programmed emergency medical holograms with humor. There's a lot that is funny about Seven of Nine, and not just over-the-top moments like asking Harry Kim "You wish to copulate?" but also in the way she handles the Treknobabble. Even her name! "What's your designation?" "Seven of Nine, Tertiary Adjunct of Unimatrix 01." Beat. "But you may call me Seven of Nine." This has the cadence of a Groucho Marx joke.

R: You've been keeping this bottled up in a containment field for twenty years, haven't you.

J: You have no idea. Anyway, with The Doctor as the more obvious comic relief, it's wonderful that they have such a terrific mentor/mentee friendship.

R: I love that, like Data, The Doctor is constantly in the process of becoming more human. It's in the subroutines Harry created for

him. And what's more human than seeing someone with a need and then helping them? Then the longer Seven is away from the Borg Collective, the less she needs the suits and contraptions he's built for her, and eventually she needs his lessons less and less. It's really quite touching. And, of course, there is that wonderful VOY season seven episode "Body and Soul" where they swap consciousness and he gets to experience having a solid form and eating for the first time. Even if they are just prison rations. What say you, Erin?

ERIN: Exactly! And one of the best things about their friendship, in fact lots of *Star Trek* friendships, is that they transform and grow in ways that make completely natural sense—much like real-life friendships do. We don't even have to leave *Voyager* to talk about this. In the third episode of season one, "Parallax," Janeway's initial frustration with B'Elanna's Maquis attitude and approach evolves enough for her to realize that B'Elanna isn't only uniquely gifted to take over as chief engineer but that the two of them could actually work well together. It makes sense for two of them to become closer because, as we've seen with her relationship with Tuvok, Janeway seems drawn to senior staff who have very different perspectives and regularly challenge her decisions. My favorite scenes throughout *Voyager* are when B'Elanna and Janeway, as a former science officer, are doing what they do best: solving problems. At times, because of their relative positions and ranks, their relationship can read more as a mentorship, but it's still a very natural friendship that deftly navigates between the personal and the professional. I think that's very much like what we see with Michael Burnham and Sylvia Tilly.

J: I love the mentorship between Burnham and Tilly, too. When they first meet, it's Tilly that shows her the ropes. Welcome to the *U.S.S. Discovery*, there's weird secret science going on here. But soon Burnham recognizes a bold future commander in Tilly, who just needs a little water and sunlight to grow.

R: At first it's like the one kid in school who is sitting alone, and it only takes one act of kindness to kickstart a great friendship. Burnham comes to *Discovery* in disgrace, Tilly accepts her anyway, and that's all they need. Tilly has nothing to lose. She has no social standing or high rank. She's only an ensign. She just sees another person alone, feeling what she might be feeling, since we later learn she struggles with

confidence issues. So many friendships begin this way, with just a simple moment.

J: Michael certainly needs a friend and grabs the opportunity, but being Tilly's friend isn't easy. She's not a great roommate. She snores, she's messy. If this was a college dorm, Tilly would need someone to hold her hair back while she's ralphing after a party. But Michael is so supportive. There they are, jogging around the ship in their DISCO shirts, right?

R: Gosh, yes. But it goes both ways. Michael comes to the ship with tons of baggage. Tilly and Burnham have one another's back, like few others do.

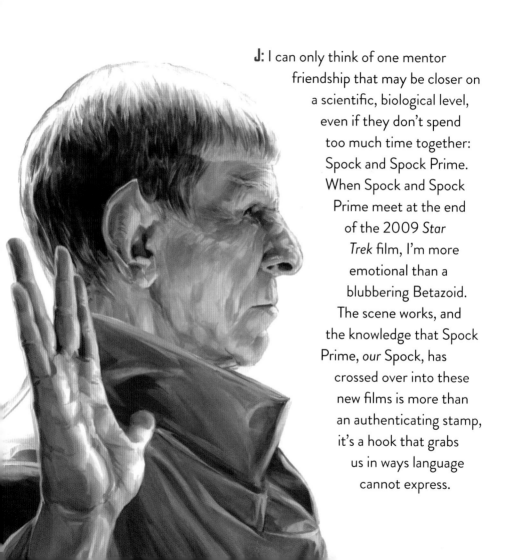

J: I can only think of one mentor friendship that may be closer on a scientific, biological level, even if they don't spend too much time together: Spock and Spock Prime. When Spock and Spock Prime meet at the end of the 2009 *Star Trek* film, I'm more emotional than a blubbering Betazoid. The scene works, and the knowledge that Spock Prime, *our* Spock, has crossed over into these new films is more than an authenticating stamp, it's a hook that grabs us in ways language cannot express.

R: I love the moment when Spock Prime and Kirk are scheming to get Kelvin Spock to show that he's emotionally compromised. Kirk is thinking there's no way he can get Spock to do that. Then there's the line, "Jim, I just lost my planet. I can tell you, I *am* emotionally compromised."

J: It's a great scene, and a great callback to TOS season one episode "This Side of Paradise," by the way. It's an unusual friendship to have: with yourself. Or maybe it's the most common of all? Something to think about! Science fiction, it'll do a number on ya. But another question, Robb, why are we being so humanoid-specific? Let's loosen up. How about the friendship between a person, or an android, and their pet?

R: Oh, yes, of course! Archer and Porthos! Data and Spot! Booker and Grudge! Sulu and . . . was it Beauregard or Gertrude the Plant?

J: Um, excuse me, Yeoman Rand may have called it Beauregard, but Sulu called it Gertrude. I think we need to go with rank there and call it Gertrude. Either way, there are a lot of great pets in the *Star Trek* universe, though Porthos is for sure the top *Star Trek* pet for me. I mean, for starters, he's such a good boy. Second, he was key to a few episodes, wasn't he? Didn't he, um, mark his territory on some planet and cause a major incident?

R: A sacred Kreetassan tree, yes, but please don't bring this up, it's very embarrassing to poor Porthos. I'm Team Porthos all the way. And even though I'm deathly allergic to cats, Spot had some champion moments, too. Aside from inspiring poetry, it was observing her deliver her litter during the de-evolution crisis in the TNG season seven episode "Genesis" that led the crew to design an antidote. And not a moment too soon.

J: I like that Spot made Worf sneeze. A sneezing Klingon is a lot funnier than a sneezing you. There's so much that's funny on *Star Trek*. I think this is something people don't talk about enough, but *Star Trek* friends talk about it all the time. Close your eyes and remember this: Planet Ekos, from TOS season two's "Patterns of Force." Kirk and Spock are shirtless and have just been whipped by Space Nazis. As such they have blood smudges on their back, and Spock's is green. Kirk has to hoist Spock up so he can create a kind of laser to blast them out of prison, and Spock is babbling about rubindium crystals while Kirk is grumbling to keep it moving. Then they start picking apart the phrase "the broadside of a barn." That, to me, in a very weird way, is all I want in a friendship.

R: I wish everyone could find someone to look at them like Kirk and Spock look at each other. Especially with a raised eyebrow.

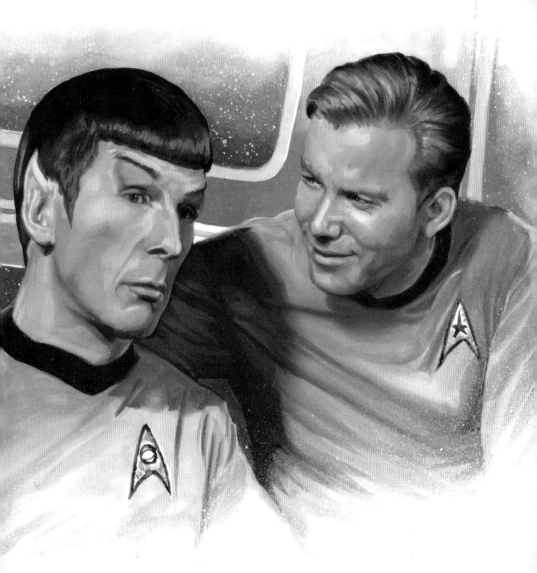

J: I can never, and will never, get enough of what Kirk and Spock have. From that first scene and the "Irritating? Ah, yes, one of your Earth emotions" line. Did Spock really not know what irritating meant? We'll never be certain! Friendship is complex, and I think that's good. If it could be easily explained, who would want it? But this conversation has helped illuminate friendship a little bit, and for that I am thankful. I mean it when I say, "I have been and always shall be yours."

R: Me, too. *Star Trek* has shown us, time and time again, that friends make everything better. The very concept of friendship made way for the United Federation of Planets, and it's the heart of Starfleet's mandate—to seek out new life and new civilizations, not to conquer them. And maybe best of all, it's brought us, and millions of other friends, together. This franchise has connected people who otherwise would never have met to share countless hours talking about all the friendships we've covered here, and I'm sure hundreds of others that we didn't have the room for. And I think, to paraphrase Admiral Kirk at the end of *The Wrath of Khan*, it's because of *Star Trek*'s sense of friendship, optimism, and embrace of Infinite Diversity in Infinite Combinations that makes *Star Trek* friends the most . . . human.